CAM AND HOPPER TRAVEL THE WORLD

Macaire + Camden

CAM AND HOPPER TRAVEL THE WORLD

MACAIRE EVERETT

Copyright © 2021 — by Macaire Everett

All rights reserved. This book is protected by the copyright laws of the United States of America. No part of this publication may be reproduced, stored in a retrieval system, or transmitted in any form or by any means—electronic or mechanical—including photocopying, recording, scanning, or otherwise (except as permitted under Section 107 or 108 of the 1967 United States Copyright Act), without the prior written permission of the author. Requests to the author for permission to use should be addressed to macaire@macairesmuse.com. Mention of specific companies, organizations, or authorities in this book does not imply endorsement by the author or publisher, nor does mention of specific companies, organizations, or authorities imply that they endorse this book, its author, or the publisher. All trademarks are the property of their respective companies. Internet addresses and telephone numbers given in this book were accurate at the time it went to press. Limit of Liability/Disclaimer of Warranty: While the author has used her best efforts in preparing this book, she makes no representations or warranties with respect to the accuracy or completeness of the contents of this book and specifically disclaims any implied warranties of merchantability or fitness for a particular purpose. No warranty may be created or extended by sales representatives or written sales materials. The advice and strategies contained herein may not be suitable for your situation. You should consult with a professional where appropriate. The author shall not be liable for any loss of profit or any other commercial damages, including but not limited to: special, incidental, consequential, or other damages.

Library of Congress Control Number: 2021908306

Publisher's Cataloging-in-Publication Data:

Cam and Hopper Travel the World; by Macaire Everett

66 pages cm.

ISBNs: 978-1-7363056-3-8 Paperback

978-1-7363056-4-5 ePub

Printed in the United States of America

DEDICATION

to my brother, Cam

we imagine together —

lifelong memories

FOREWORD

At what point in time does one realize the gift they possess and share, is as much about the gift they receive back from the exchange? You will find for Macaire and Camden it is at a very young age.

This sequel touches upon the creative process, the inclusion of one's sibling and their playful adventures, and shared dreams of travel that resonates across cultures. Chalk, the chosen medium, was used as long ago as humans started drawing with charcoal on cave walls. It is only recently that technology has allowed us to capture moments in time from unique vantage points (think drone). These vantage points must be calculated by Macaire prior to her start. The spatial math required and combined in the end with the digital capacity to capture and share in seconds with others across the globe is quite a juxtaposition to her artwork and poetry.

In talking with Macaire, it is the nature of these unusual juxtapositions that fascinate her. Her natural inquisitiveness and creativity led her to write original haiku to accompany the pictures that she and Camden realized. Macaire's poetry is made to invoke imagery and expand on it for the viewer. This resonates with the Japanese visual poetry form of haiga. Like haiga, her poetry blends her playful pictures with profound observations of life and the living world around her. To use half of William Blake's opening quatrain, poetry invites us to see a "world in a grain of sand" and "heaven in a wildflower".

In fact, this is no mere picture book. But rather an art book that invokes dreams of faraway places and of real actors, not imagined, who you can revel in and relate to. It is not a backdrop of staid pictures. Rather what you hold in your hands is a quartet of pieces harmonized together as imagined by Macaire and Camden.

Each page is a chalk drawing, enhanced with a haiku, and includes an adventurous brother with his stuffed rabbit, Hopper.

It is a gift.

Michael B. Stanczak

INTRODUCTION

I have been creating massive chalk murals on my driveway since March 2020. This art project started as a way to entertain my little brother, Cam, who poses in each mural, bringing it to life. Cam and I set and achieved our initial goal of creating chalk art for 101 consecutive days and shared that journey in our first book, *The World From Our Driveway*. I was inspired to create our first book to chronicle all that we accomplished, and we were thrilled that others around the world discovered our art and requested more adventures.

As awareness of our art spread, amazing opportunities to connect with others emerged. I was thrilled that my community asked me to paint a mural in our town. In addition to this being a great learning experience, this project enabled me to create art that was more permanent than the chalk art we kept washing away. Cam and I are also thankful to a new network of friends who post encouraging comments on social media. Some teachers who follow our work connected us with their students. Cam and I had the honor of joining classrooms virtually in Norway, Italy, and the United States to meet kids our age and talk about our shared love of art. We hope opportunities to connect with educators and students continue.

All of these experiences inspired Cam and me to continue creating our art, which led to the images included in this book. I wrote haiku to accompany each piece to further tell its story. We hope this book grows your appreciation of art, travel, adventure, and poetry.

Macaire Everett

A Boy and His Bunny II

Cliffs of Moher, Ireland

the beginning of

an exciting adventure

starts with a true friend

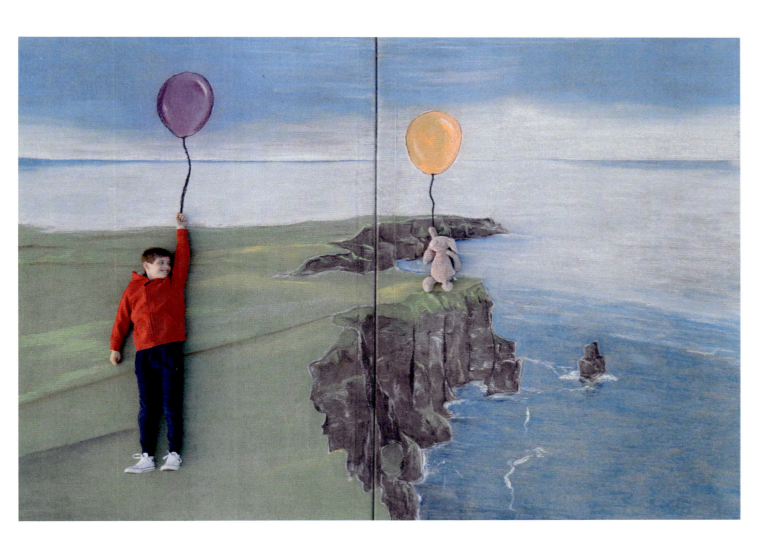

Mid-hike Snack

Grand Canyon, Arizona, US

sun's rays bouncing off

deep canyon — flowing water

warms the heart, calms soul

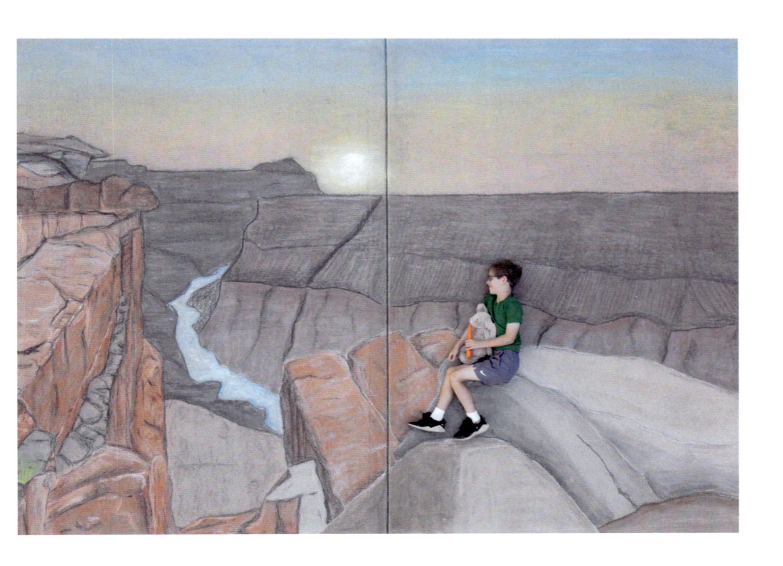

Island Hopping

Waimanalo Beach, Hawaii, US

 waves bring fresh treasures

 each time they sweep over feet,

 wet sand in my toes

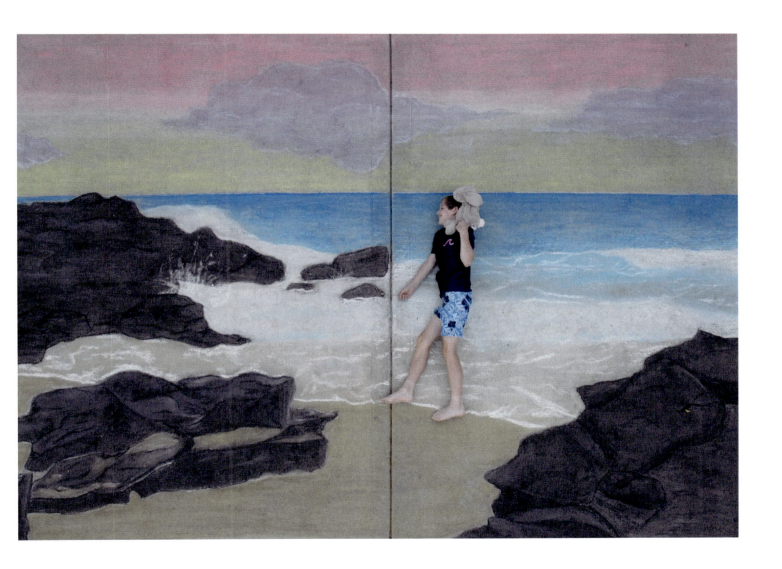

Soaking up Summer

Cannes, France

floating with no plan

for the day — sipping slowly —

taking it all in

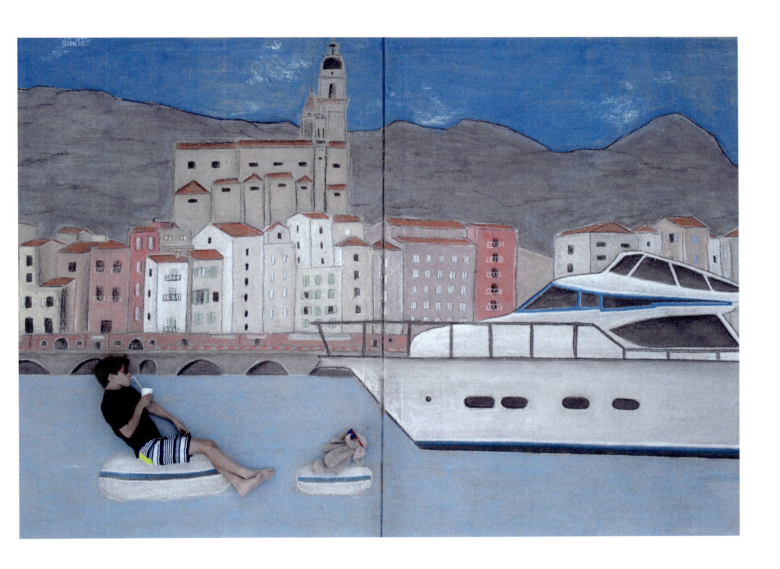

Stargazing

Pangong Lake, Leh Ladakh, India

twinkling shining

billions of ways to connect

bringing us closer

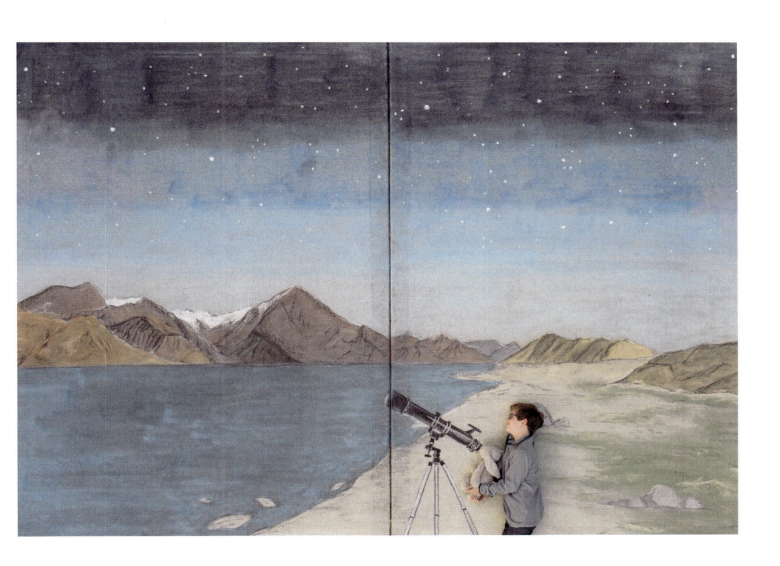

Teamwork

Loch Leven, Scotland

sometimes you may think

you give more than others, but

there's no score to keep

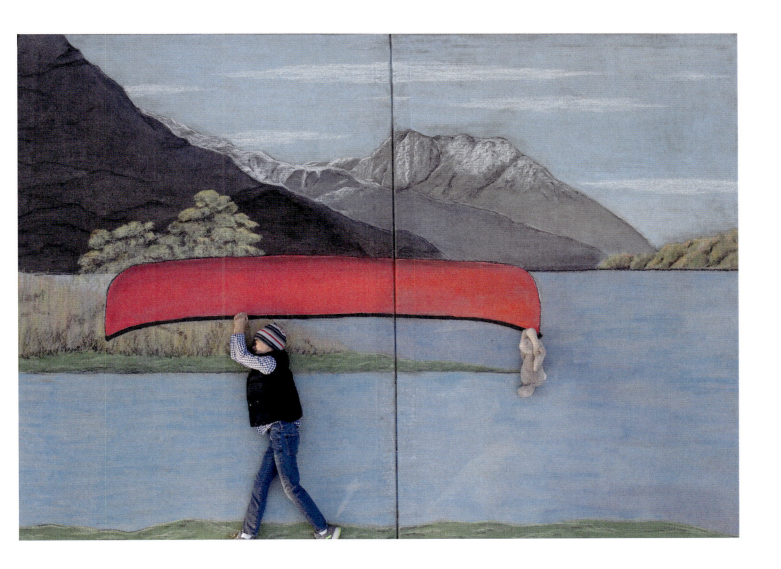

Reflecting
Western Wall, Jerusalem, Israel

faith-filled thoughts and hopes

to our brothers and sisters,

united by love

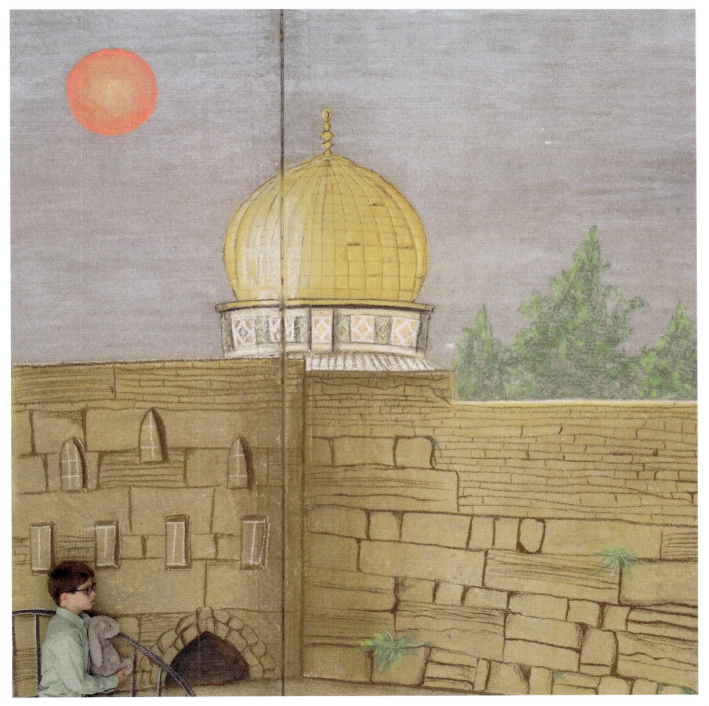

Hiking with Hopper

Aspen, Colorado, US

the more we climb, the

fresher the air, and lighter

the weight of our thoughts

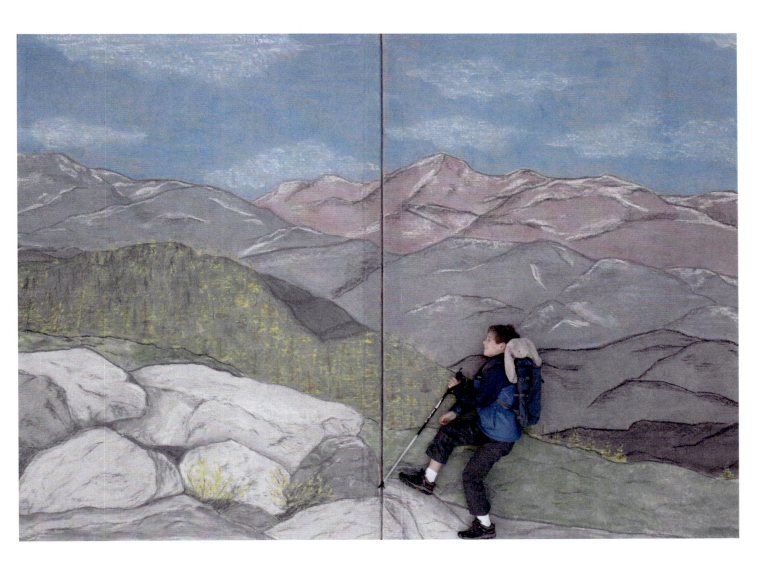

Polar Plunge

Antarctica, South Pole

the thrill of a race,

competing with slick penguins

our barren swim meet

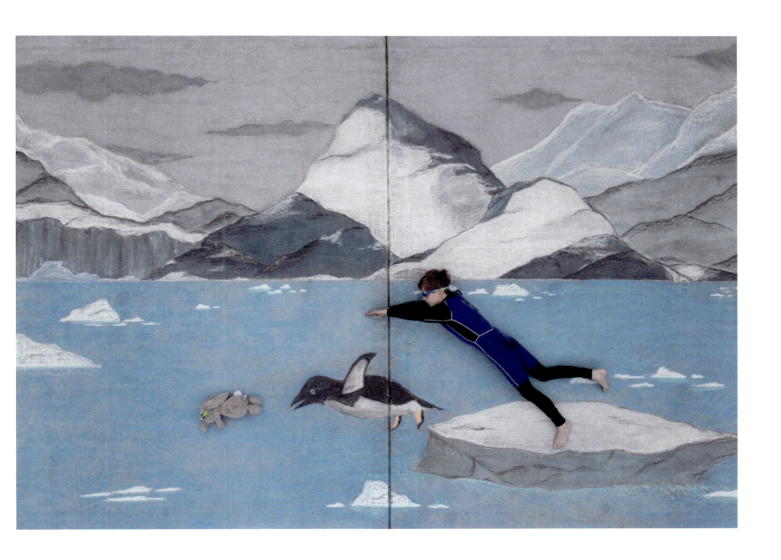

Trick or Treat

Sleepy Hollow, New York, US

a generous friend

with more treats than we can eat —

happy haunting all

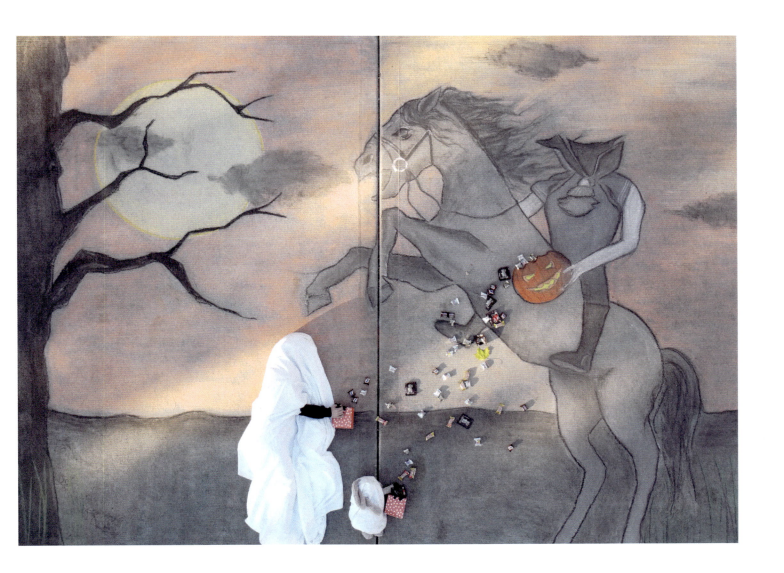

Nordic Night Ski

Sveio, Norway

gliding through powder,

guided by the colors of

nature's wavy lights

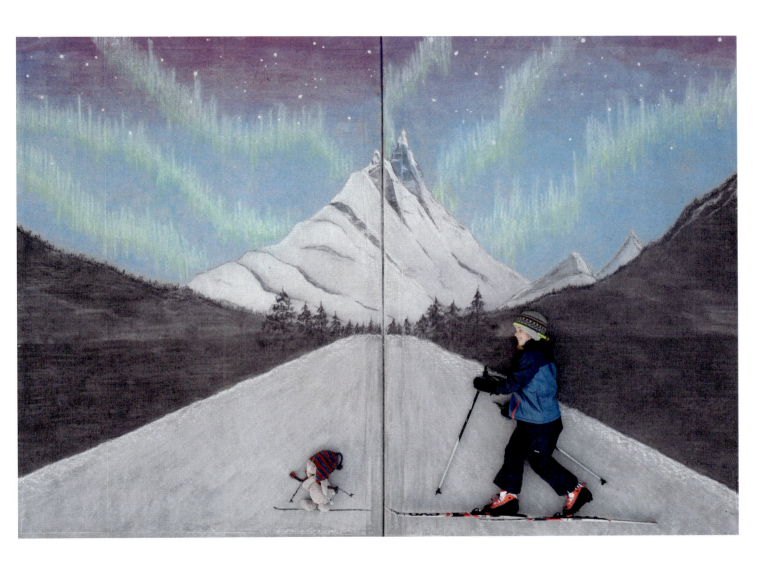

A Day on the Lake

Brienz, Switzerland

feeling lake breezes

the mild sun, the rocking boat —

but no tug on line

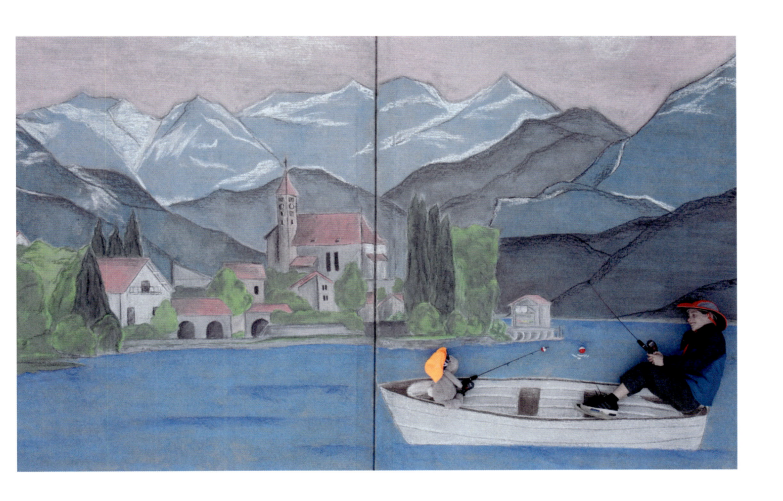

Cocoa at Christkindlemarkt
Nuremberg, Germany

 hot chocolate makes

 the winter season festive

 tastes best together

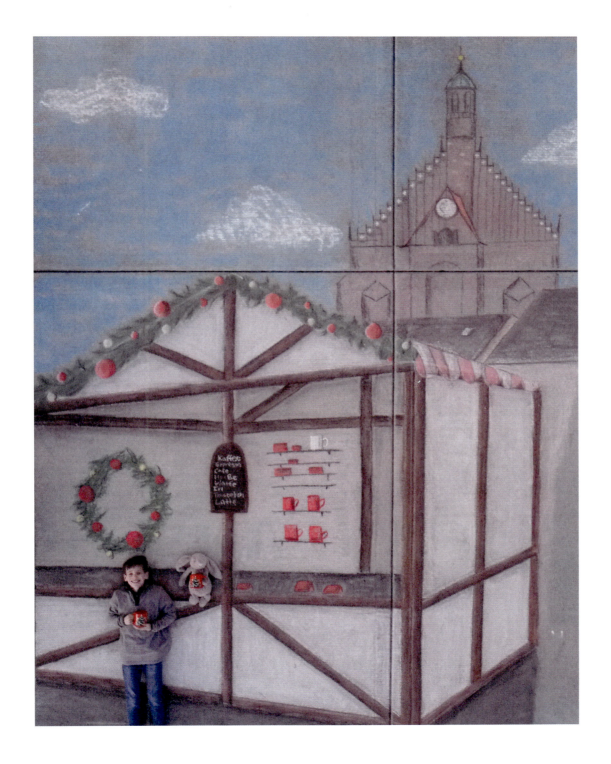

Open Air Skating

Banff National Park, Canada

always protecting

blocking him from windy gusts

friend priorities

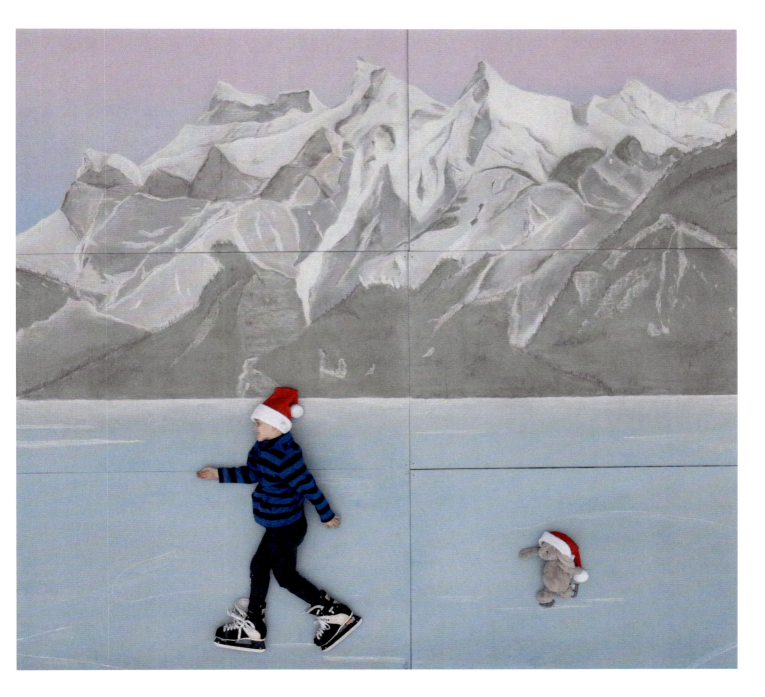

Light in our World

St. Peter's Basilica, Vatican City, Rome

candles guide the way

to happier days ahead

grateful for the light

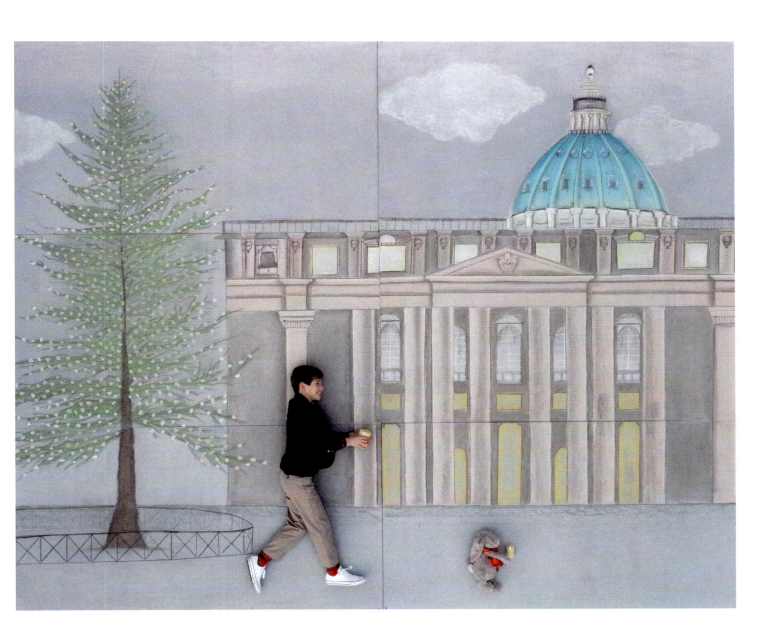

Ultimate Joyride

North Pole

who can say they flew

on the wind of his reindeer —

we'll return it soon

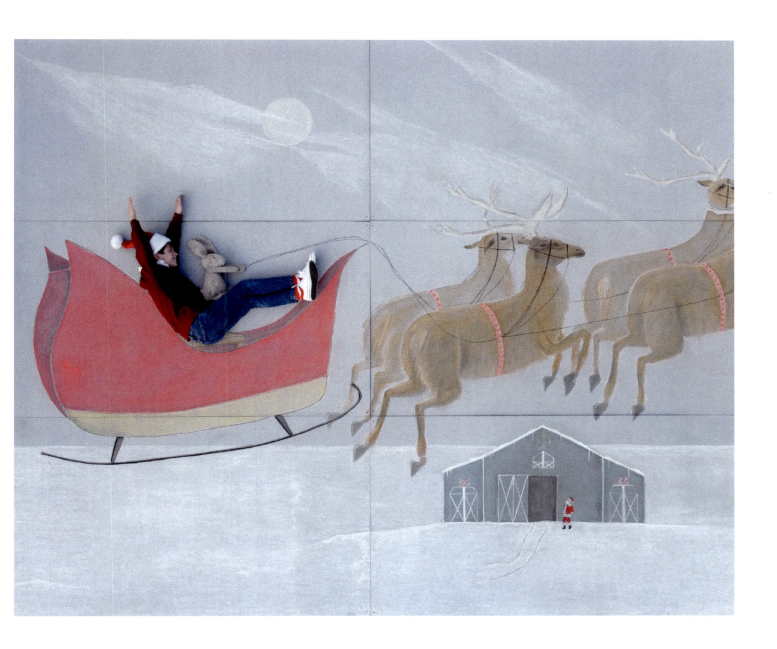

Sailing into the New Year

Victoria Harbour, Hong Kong, China

beginnings require

party hats and confidence

cheerful traditions

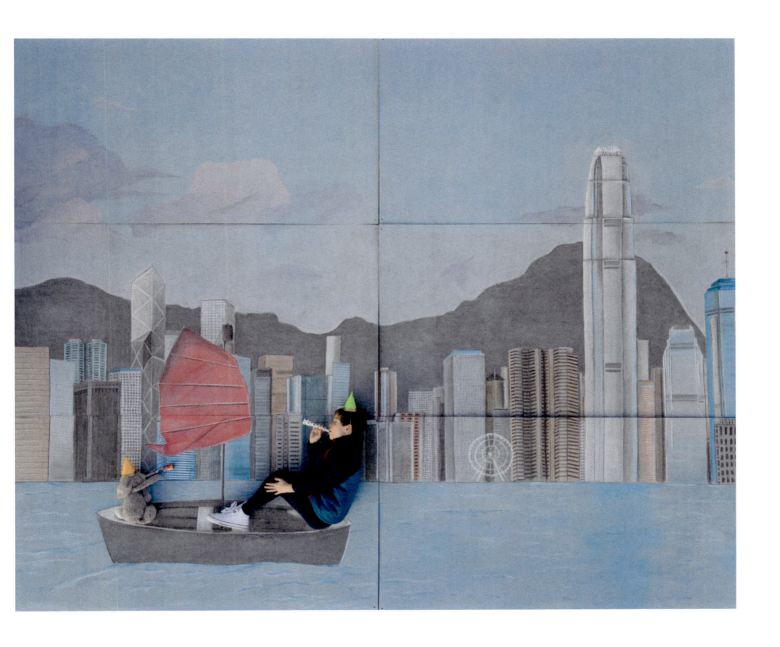

Achieving
Sagarmatha National Park, Nepal

the best can be done

when we do it together —

common goals conquered

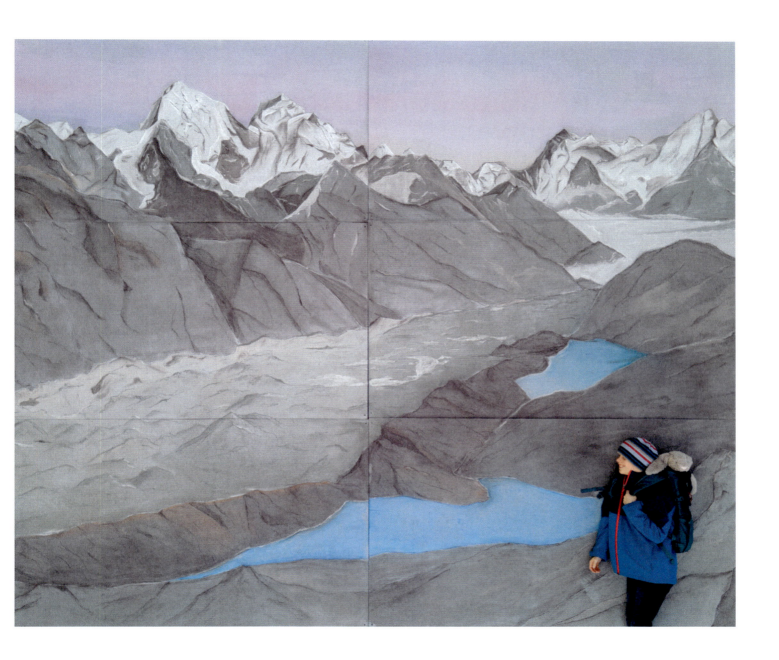

Splash

Adelaide, South Australia

anticipation . . .

the fresh chill of the water

adrenaline high

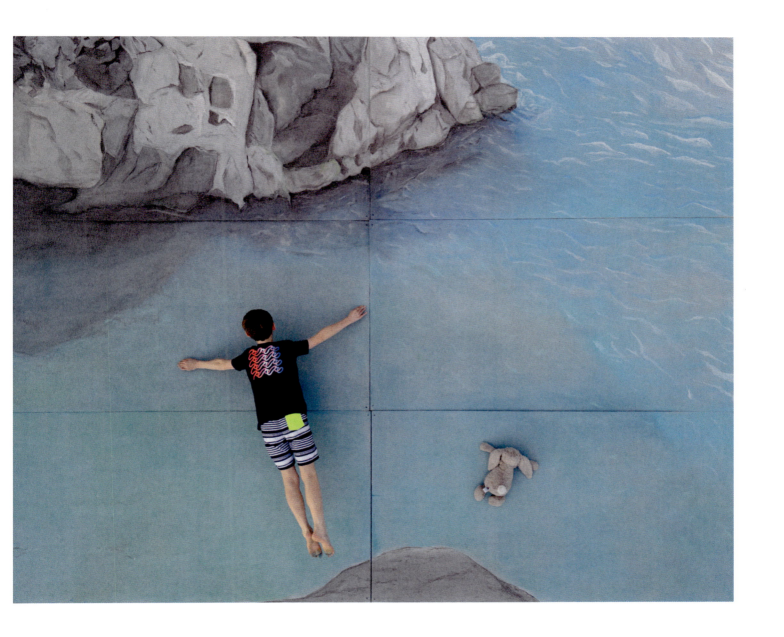

Uplifting View
Kruger National Park, South Africa

they plod forward while

we crouch and breathe in silence

majestic presence

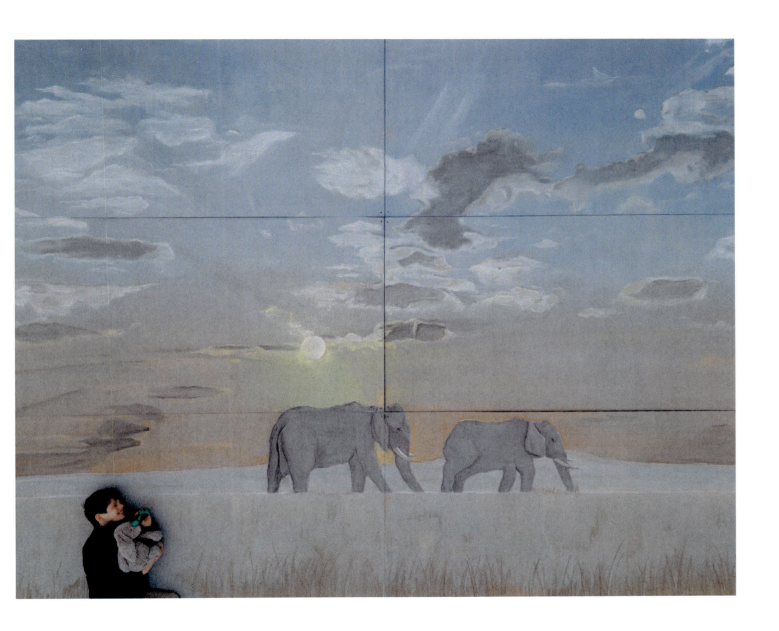

Pow
Sölden, Tirol, Austria

unique views can bring

exhilarating outcomes —

be open to seek

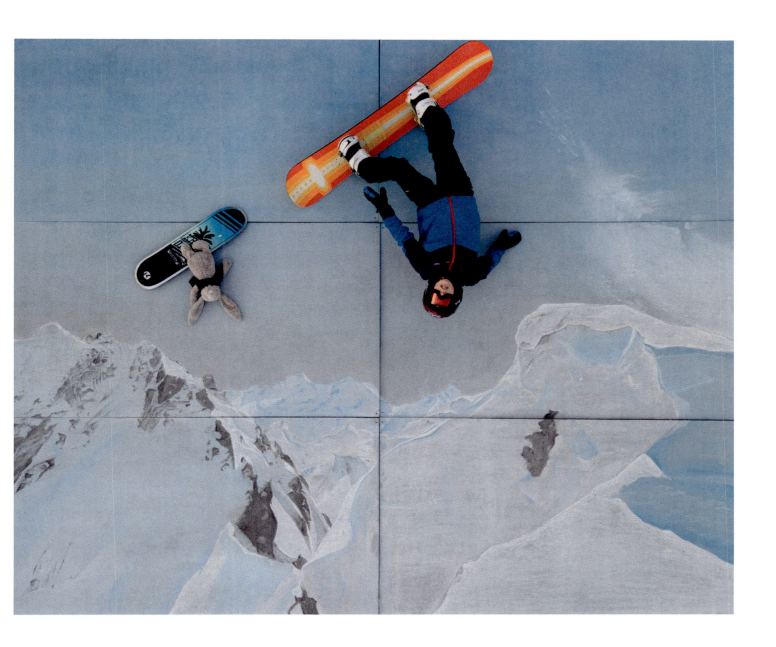

What's Next?

Florian, Colombia

approaching the top

feeling accomplished, restless

pondering next goal

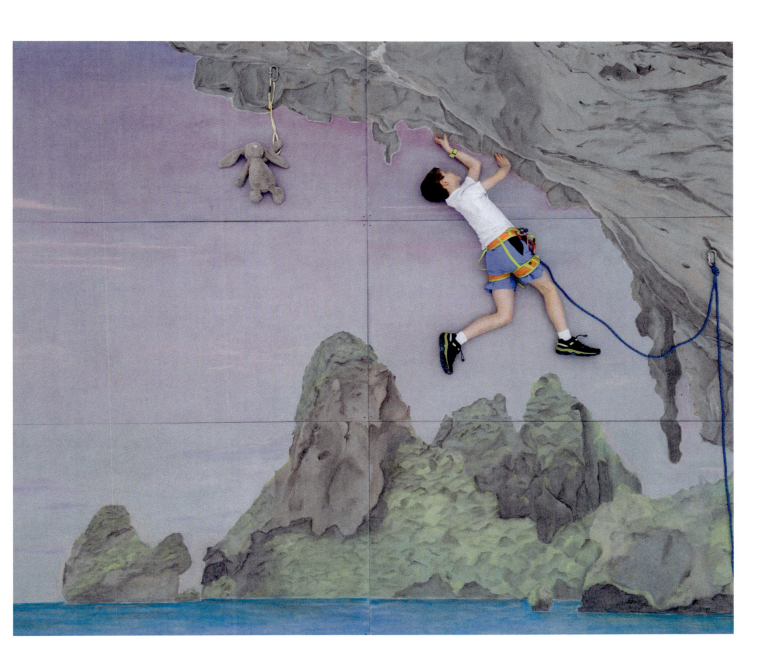

Floating On

Cliffs of Moher, Ireland

our boredom evolved

into creativity . . .

a gift to the world

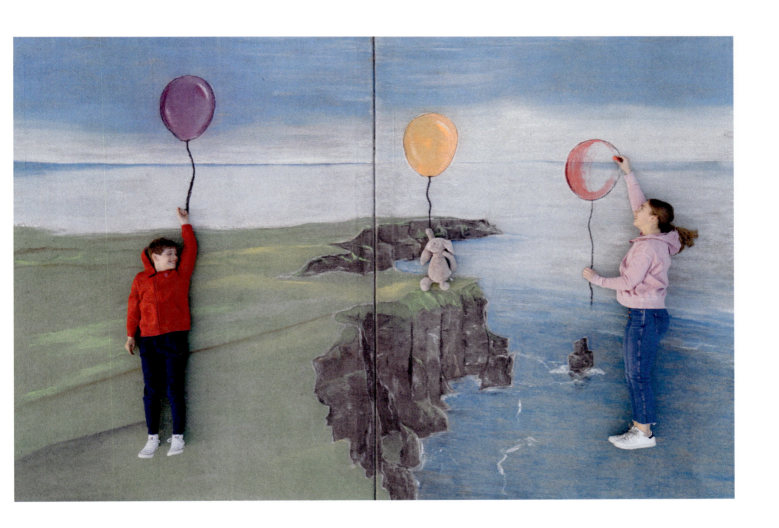

Behind the Scenes

Indoor/Outdoor Studio

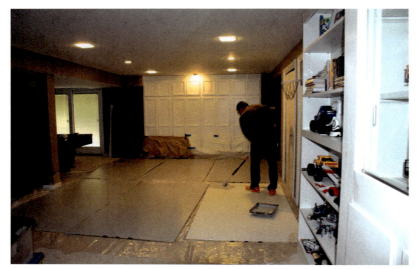

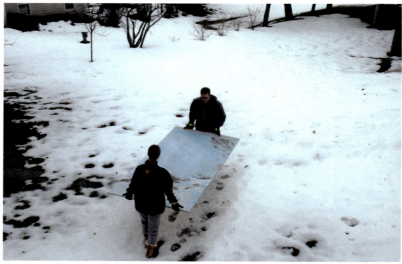

My Dad designed a way I could chalk indoors during the winter and still take the picture outdoors on our driveway. Our basement was rearranged to accommodate six sheets of plywood that together measured 12' by 16'. Dad primed and painted them to match the color of our driveway.

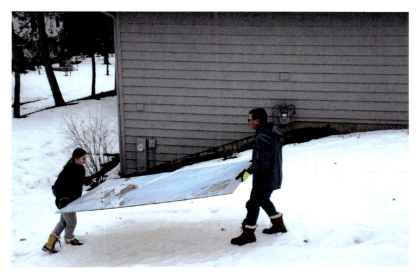

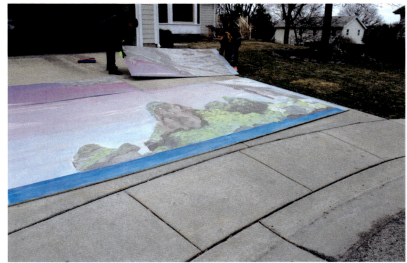

After I finished chalking, my Dad and I carried each plywood sheet outside and arranged them on the driveway to look like a single piece. After Cam and Hopper posed, Dad flew the drone to take the picture. Each plywood piece was then carried back to the basement and cleaned for the next drawing.

Behind the Scenes

New Chalking Techniques

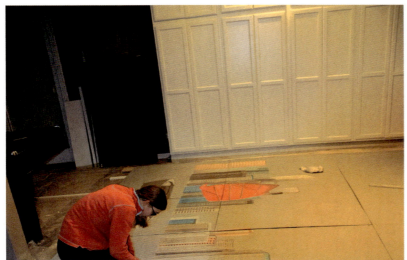

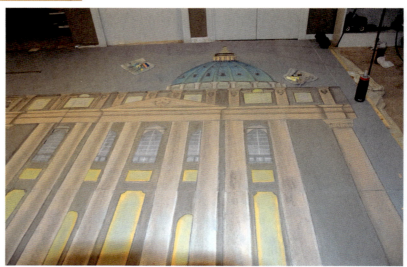

I liked chalking indoors because I didn't have to finish the art in a single day and wasn't concerned about the weather. I started adding more depth and shading and took more time to complete each piece. Chalk doesn't blend well on plywood, so I adjusted my technique.

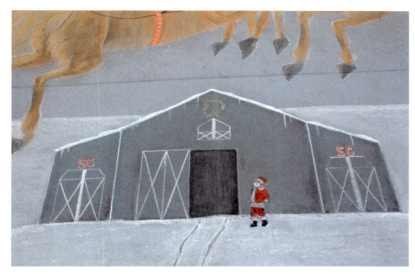

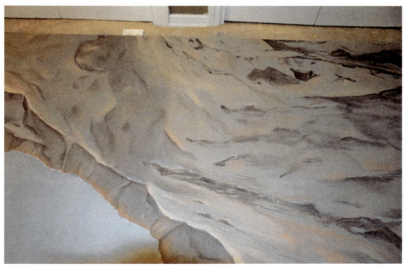

My biggest challenge was balancing the additional time I was spending on each piece with my plan to complete and share new art weekly. I think the realism of the final piece was worth all the time and effort.

Behind the Scenes

Advanced Posing

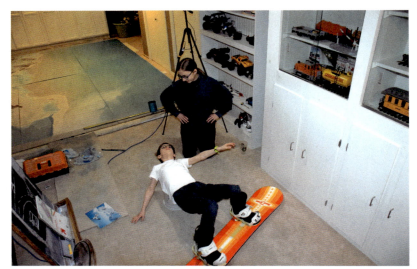

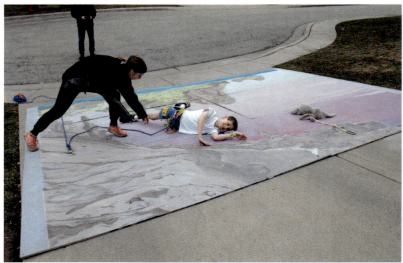

Cam's expert poses are the reason the pictures look so realistic. He practiced every pose in advance inside to minimize the time spent outside.

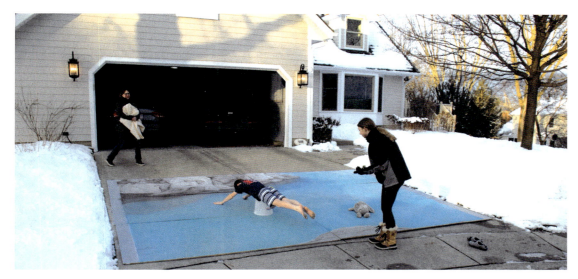

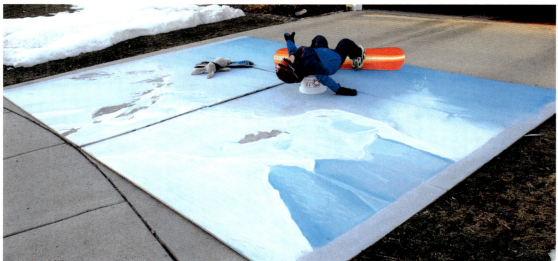

Cam braved the cold and patiently adjusted to ensure the best result. The day he went cliff diving it was 20°F. For these two poses, he's balanced on an overturned bucket, bringing depth to his body position.

AFTERWORD

It all started in July 2020, when I, a Norwegian teacher, was working on my Arts and Crafts school plan for my class of upcoming sixth graders. I was scrolling through Instagram and there it was! Multiple chalk art drawings made by two pupils and siblings from Illinois in the USA. I could not let go of their pictures and chalk arts, and a project idea for my class started to form inside my head. This idea, "My Dream", got its roots because I saw the great development in Macaire's drawing skills. Macaire and Cam's story and plan of making 101 consecutive drawings remained in my thoughts. I decided that those two children would be the perfect role models to the pupils in my class.

In the middle of August I informed my class of what exciting plans I had made for them in Arts and Crafts. I showed my class all of Macaire's drawings and we watched different interview clips from American tv-programs. Based on Norwegian weather, I decided that my pupils would draw on paper, and I would take a photo of them in front of a neutral background wall. The photo of themselves, dressed so that they fit into their drawing, would then be cut out and glued into their drawings. Their drawings were then scanned into a digital form, while the paper form got laminated.

While my class was working on this project, I was thinking more and more about what if my class could meet and talk to Macaire and Camden. In October 2020, a message was sent to Macaire's Muse on Instagram, requesting if this was possible.

Our first virtual meeting, on October 30, 2020, was overwhelming for my class! They were ecstatic and a friendship was established immediately. The class was well prepared with questions for Macaire. A second meeting happened on February 5, 2021, and my class got to present their drawings. This time, both Macaire and Camden had the opportunity to participate. Their conversation was almost like one with long lost friends. The pupils discovered that they had lots in common with the children from Illinois! Even though we are in different parts of the world!

As a teacher, I am so happy to be a part of this project and glad it all went so well. To be able to watch and experience the pupils' joy at drawing their dreams and getting to meet two 'proper' American children and get to talk to them, in English, really warmed my heart! It is so important that every pupil get to experience mastery in school and get recognition for what they do. By naming the project "My Dream" I also got to know my pupils in a deeper level, and by doing so, catching up on what is important for them (also in other subjects) and use it whenever I can, in order to make subjects more interesting and relevant to the pupils.

There are so many ways to tell their story, their desires and dreams. Not all children are born academics, but everyone has something artistic inside them that should be allowed to come out. Drawing can have a lot to say, both for their desire to convey something, but also in connection with the development of fine motor skills. And for some, drawing is also a way to escape from their everyday challenges and difficulties. This time, that the whole world is experiencing right now, Covid-19, has done something with all of us. And by drawing a dream that might come true, or not, can help us look for the positive and focus on everything being good in the end.

We appreciate our friendship with the Everett Family, and hope that one day we can meet in person. Macaire and Camden are doing fantastic artwork that is known worldwide and has contributed to cheering many people in this difficult time. Thank you so much for doing so!

Greetings from 6B at Sveio skule, Norway

May Lende (teacher)

Alexander, Andrea, Andreas S.A., Andreas R., Benjamin, David, Emil, Emin, Eva, Gabriele, Ihne, Jayden, Kasper, Liam, Luna Aurora, Marta-Soraia, Martin, Mathilde, Ronja, Sakarias, Sebastian, Sophie Aimèe and Thea.

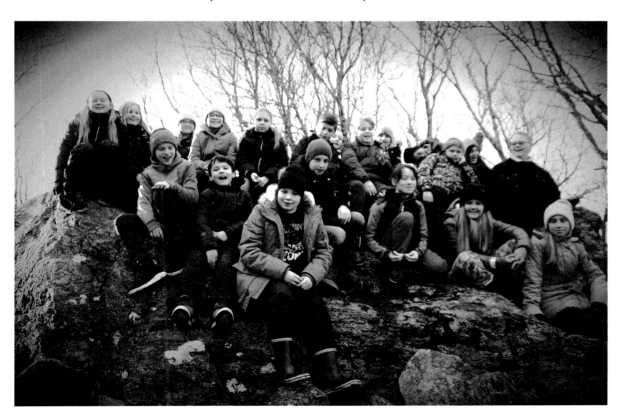

INSPIRING WORDS

Cam, Hopper, and I are grateful for all the encouragement we receive from our family and friends around the world. We value the time each person takes to: tell us how our art is meaningful, thank us for our efforts, and comment on their favorite part. Although we couldn't include every inspiring comment we received in this book, each of them motivated us. Here's some of the comments that energized us to continue chalking and create this second book.

"Amazing dedication. Amazing drawings. Amazing kids."

 - Bill Skeens, US

"We've all seen chalk drawings on the sidewalk during the recent confinement. One young artist and her younger muse took it to an unparalleled level. What fifteen-year-old Macaire has achieved is just so impressive, full of magic and love. Please someone give those two an award, a scholarship, a thumbs-up. As far as we are concerned, they have already made pandemic history. These ephemeral and monumental images cannot be preserved in their original state. Luckily, we have social media."

 - Léo Beaulieu, Collection Internationale Desseins d'enfants, Canada

"When I first discovered the work of then fourteen-year-old Macaire Everett, I was stunned by her sheer talent, vision and creativity. I also found It so interesting to see how Macaire and her brother Camden had adapted to the circumstances of the pandemic, as we joined them in the fun of their daily travels of the imagination. She spread the cloths of her imagination under her brother's feet, and we traversed the globe with them both. But on reflection the impact and importance of what they have done has ramifications far beyond just that. When we eventually look back at 2020/2021 what will stand out for me are all the kindnesses. From simple things like people going out of their way to help neighbours, paying for someone's groceries in the supermarket, the wonderful 'on the ground' work of voluntary and charity organisations to large-scale asks, it is the instinct for, the capacity for kindness of human beings that stands out. And this story of Macaire and Camden, is ultimately a story of kindness.

It's a story of sibling love and respect. A story of one person putting another first, and trying their hardest to make life just that little bit better, that little bit easier for them at a very tough time. Macaire used her incredible talent to help. But what of Camden, Macaire's muse? His part is incredibly significant. Yes, he is the inspiration, and that's huge, but without his willing and active participation in the adventures that Macaire devised, they wouldn't have happened, wouldn't have come alive as they did. They have had a wonderful time of fun and cementing their relationship for life. This is a fabulous team effort. Born from mutual love, it is empowering and inspirational. If we were to each remember to try to put others first, what a significantly better world that would lead to.

I think this poem from Yeats is an apt one in this instance, as the artist asks the person upon whom he is bestowing his gifts, to accept and honour them. Macaire bestowed her artistic gift on Camden, but together, working as a team, they transcended the original gift and created magic.

> "Had I the heavens' embroidered cloths,
> Enwrought with golden and silver light,
> The blue and the dim and the dark cloths
> Of night and light and the half-light,
> I would spread the cloths under your feet:
> But I, being poor, have only my dreams;
> I have spread my dreams under your feet;
> Tread softly because you tread on my dreams."
>
> - W. B. Yeats.

We can't wait to welcome Macaire and Camden to Ireland post COVID-19. The Museum of Childhood Ireland (museumofchildhood.ie) is looking forward to hosting the first physical exhibition of their work."

- Majella McAllister, The Museum of Childhood Ireland

"Meeting Macaire and her artworks has been a great experience for me and my students. During the video call we were excited to show our chalk art projects to Macaire. I'm really grateful for her kindness."

- Lara Scandroglio, Olona International School, Italy

"It was interesting to meet Macaire and her brother Cam, Her chalk artworks are amazing! We learnt a lot from her."

- Student, Olona International School, Italy

"Your chalk art is beautiful, whimsical, and clever! We got to travel and have fun with new friends (Cam and Hopper) when we were housebound during the pandemic. Your art was a much-needed escape for all of us and became a symbol of hope for better days ahead. Thank you for sharing your talent with us! We can't wait for our next adventures."

- Walden International School, Canada

"Cam and Hopper are fearless!!! So cool. I hope you and your brother and his rabbit get to go to all of the places you have depicted. This is going to make a super book and portfolio for you. I do not think you realize how developed your layout, planning, and execution skills are. You really are training yourself... the time constraints you set for each one is forcing you to advance your skills and speed. I am truly impressed."

- Lyn Rosenberg-Johnson, US

"This. Is. The. Coolest. So much beauty, energy, and movement – well done!!"

- Mary Gilding, US

"You can help change the world. Macaire's way with light is inexplicable – she has such a gift"

- Cheryl Kennedy, US

"Congratulations team Everett! One year ago the world became a place we did not recognize. We soon found out what was most important to us and what was not so important. Love of family, friends, neighbours grew stronger. Art, music, and literature connected us more than ever before. You have been a bright light! Thank you."

- Anna Fraser, Canada

"Cam and Hopper really are the world travelers. You guys always do such a fantastic job."

- Wendy M Kunkel, US

"Lindo demais parabens"

- Angela Zuim, Brasil

"What an incredible adventure Macaire and Cam have taken us on in 2020, in a time where we were no longer able to travel, we have seen the sights and our homeland represented with so much love and detail. Every time we see one we are amazed and think that there is no way they can get any better, yet the next one always is!"

- Katrina Tucker, Australia

"These are so cool. The fact that do them with your brother says something good about you."

- Mike Donovan, US

"I almost feel as if I'm there."

- Yuki, Japan

"Your work continues to get better and better! I have been a fan from almost the beginning and as a professional artist and illustrator myself, I can totally appreciate what you are doing and the skills you continue to develop. I can't wait to see your work continue to grow over the coming years."

- Stephanie Glazer, US

"I am so impressed by all of your chalk drawings!!! You are truly a talented artist! I also appreciate how you started this for your younger brother. Keep doing what you're doing… thank you for bringing smiles and joy, not only to your brother, but to all the people that get to enjoy your beautiful work!"

- Audrey Hildebrand, US

"I'm sitting here shaking my head; you are truly amazing."

- Dee Clark, US

"Wow. Once again you've touched my heart with your talents!!! Thanks for sharing it with all of us!!!"

- Rebekah S Rice, US

"Just awesome!!!! Great precision! :)"

- Srinivas Prasad Jagannath, India

"I showed your book to our grandkids and they loved every page and marveled at your imagination. Glad you made something wonderful out of such a terrible year. Hugs."

 - Doug Lyda, US

"Brilliant work."

 - Garvit Sharma, India

"Many of my world travels have been captured by your artistry. What an amazing adventure you have created and the bonding you have shared with your brother is priceless. Thank you for this gift to all of us. You both make not traveling, bearable."

 - Peg Begley, US

"These are fabulous! Thank you for sharing your talent with all of us. It is always a bright spot to see your pictures."

 - Tina Toney, US

"Joy to your family this season. You've brought it to me this year. Thank you."

 - Sue Nevler, US

"So happy you have your beautiful art in a book. You have a positive impact on our world. I have been in awe of your work from day one. Bravo."

 - Elin Quinn, US

"Congrats to you both for being amazing kids and taking the world by storm! Keep on doing big things!"

 - Katie Fox, US

"You have a well-traveled driveway."

 - Nancy Blue, US

"Wow!! This is so amazing. Congratulations to you and your brother. You both bring so much brightness into our world. Impressive how a simple chalk can make a big difference."

 - Jerrie Cadelina-Chung, US

"I hope the world gets to witness your amazing talent"

 - Stephanie Edwards, Canada

"Every time I see your work I say to myself 'this is her best yet!' And it is. But with this? You've outdone yourself. Wowww!!"

 - Stephan Wojnar, US

"It's awesome to see your work. And for us, here in Cape Town, it's beautiful and happiness to look at what you are creating. Thanks a lot for sharing your 'view of the world'! Lovely greetings from Cape Town."

 - Karina Marmann, South Africa

"Cam and Hopper!"

 - Terri Schepis, US

"The sheer magnificence of all the works of art you have created this past year is truly beyond compare! You have made the most magnificent lemonade and it's an honor to be in your audience. Thank you once again for sharing your creativity with us all."

 - Robyn Newman, US

"Last year we had such a drastic lockdown I didn't leave my house for 9 weeks and we couldn't even walk our dogs. I felt so isolated but your daily posts gave me something so special, I really can't thank you enough for them."

 - Debbie Catanzaro, Italy

"Every new one becomes my favorite. Just awesome. Hopper is such a wonderful added touch. He's taking the lead in this one. What amazing talent and imagination. I really can't think of a more delightful way of spending this last year. Such a wonderful expression of creativity and plain ole wonderful fun. Truly a bright spot."

 - Jan Berry, USA

"Oh my goodness! Looks 3D. Had to notice the driveway lines to make sure it wasn't real!"

 - Suzanne Joy Kreider LeVesconte, US

"I love love it! This entire project a pandemic silver lining"

 - Erin Armstrong, US

"And how much joy you have brought to each and every one of us who are following! Thank you, Everett family, by showing us how to work and play together, how to lift up those who need it, and for sharing your incredible talent with the world!"

 - Renee Zorc, US

macairesmuse

Now that you've finished reading *Cam and Hopper Travel the World*, I'd love to hear what you thought of it! You can do this by writing a review on *Cam and Hopper Travel the World*'s Amazon listing to help other readers find the best book for them, and to let me know which chalk art images were your favorite!

If you aren't already traveling with us, we invite you to come along!

- 🌐 macairesmuse.com — See all our art and help us donate this book to educators.
- 📷 @macairesmuse — See our latest art.
- ▶ macairesmuse — Watch time-lapse videos on how I create many of these drawings from start to finish.
- ♪ macairesmuse — You can also watch the time-lapse videos here.

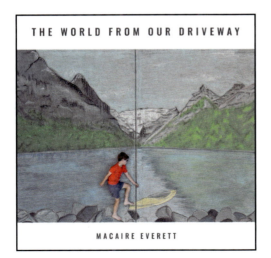

THE WORLD FROM OUR DRIVEWAY

Join my little brother, Camden, as he explores the world and takes many daring adventures—all from our driveway. In the pages of this book you can "travel" with Cam to see the world through a chalk-filled lens. Experience over 115 adventures, including walking the Great Wall of China, rocketing to Jupiter, skipping rope with kangaroos, driving a gondola, ziplining over Niagara Falls, riding a jet pack over an active volcano, scootering in Russia, golfing in Scotland, getting abducted by aliens, and many more. Cam and I hope these pictures inspire your love of adventure, and remind you of places you have visited. We've also included several behind-the-scenes images to show how each chalk art piece is created. Happy adventuring!

AVAILABLE AT ALL MAJOR ONLINE RETAILERS.

Made in the USA
Monee, IL
14 June 2021